Simon finds a treasure

Gilles Tibo

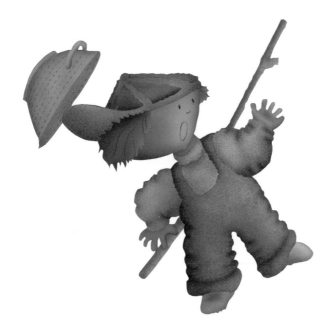

Tundra Books

My name is Simon and I love to look for things.

I take my telescope, I put on my helmet,
I get on my horse and ride out across the fields
to look for a treasure.

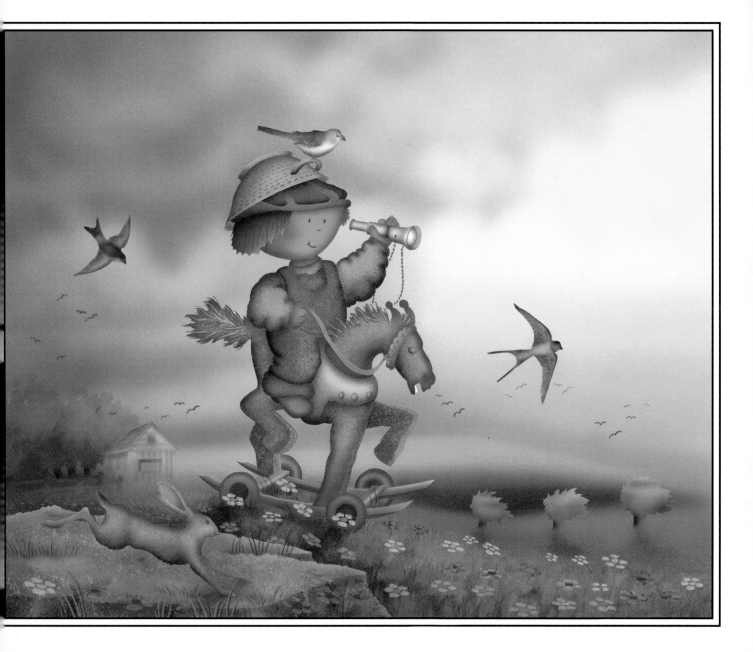

Oh! There's a sign!

An arrow points to a trail.
It must lead to a treasure.

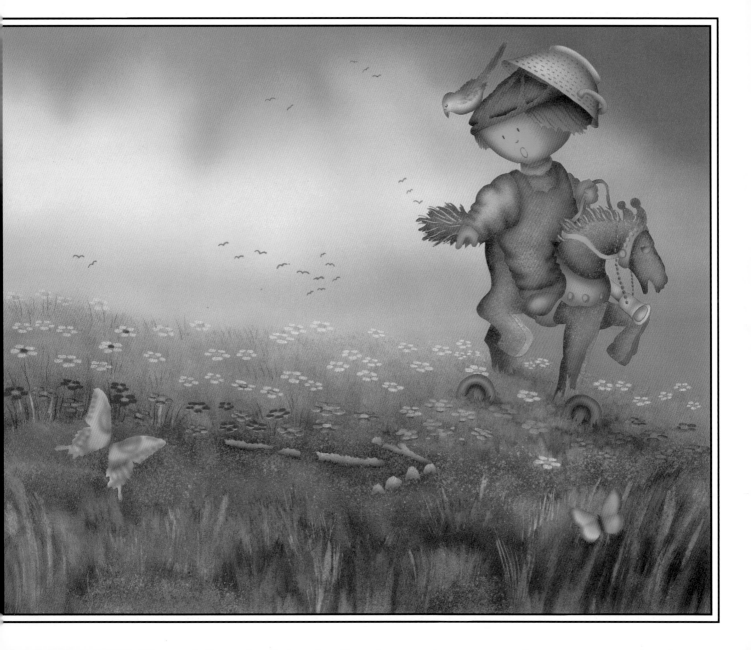

I call Marlene.
We search the field. We look for more signs.

A butterfly tries to help.
"I have a treasure," the butterfly says.
"It is hidden in the nectar of this flower.
What treasure are you looking for, Simon?"

"I don't know," I answer. "I am still looking."

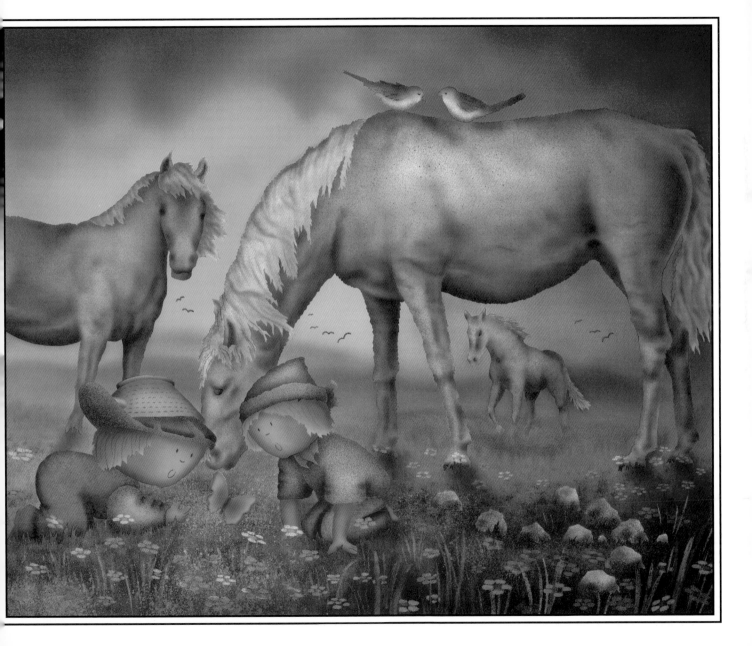

Near a pond Marlene asks a turtle to help.

"I have a treasure," the turtle says,
"and it is the most wonderful in the world.
These ten eggs that will soon hatch.
What's your treasure, Simon?"

"I don't know," I answer. "I haven't found it."

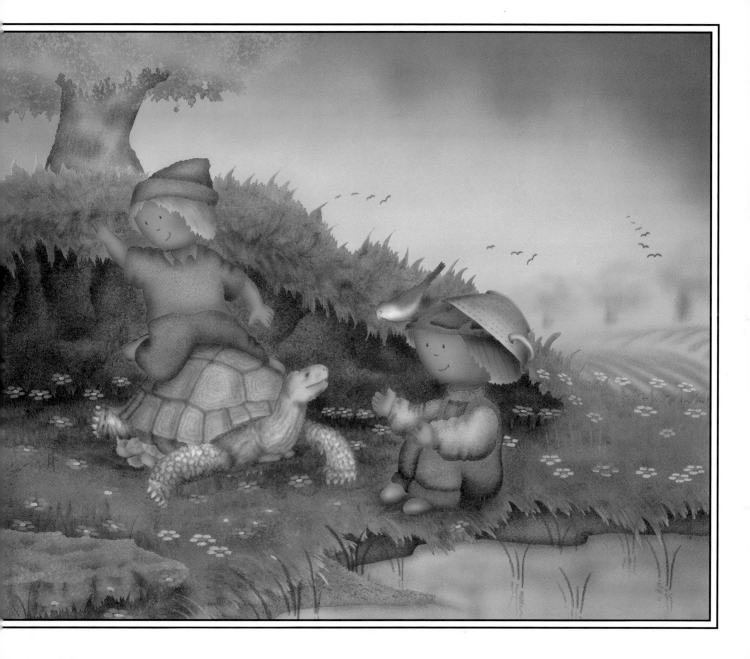

At the foot of a tree we ask a squirrel to help.

"I have a treasure," the squirrel says.
"These hundred nuts I have hidden away for winter.
What treasure are you looking for, Simon?"

"I don't know," I answer. "It's still hidden."

Marlene goes home. I go on alone.

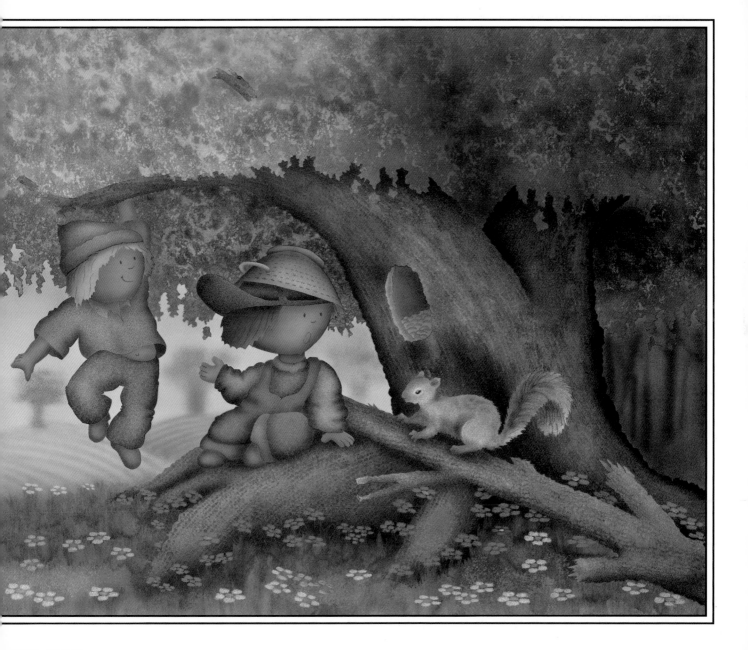

In the late afternoon at the edge of a river,
I meet an old miner.

"Look at the treasure I've found," he says.
"These thousand specks of gold dust shining in my pan.
What treasure are you looking for, Simon?"

"I'll know when I find it," I said, and go on.

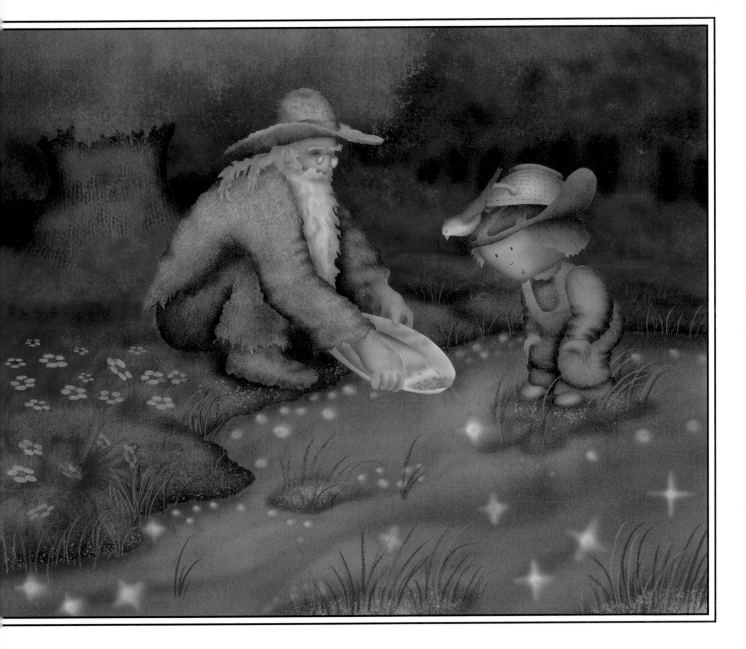

At the end of the day I reach the edge of a forest.
An arrow points to the entrance of a dark cave.
This is a place where my treasure could be hidden.

I go in.

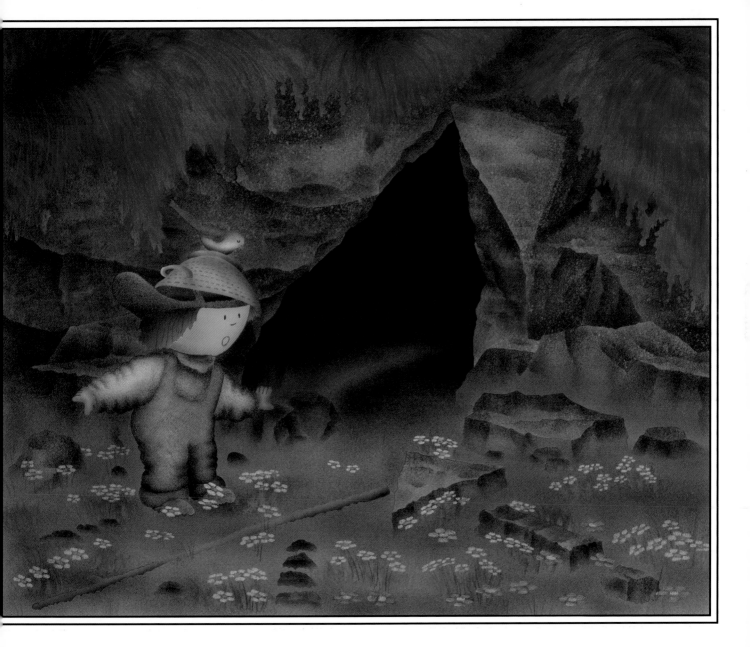

I walk a long time, deep into the cave.
I hear strange noises.
I am scared.

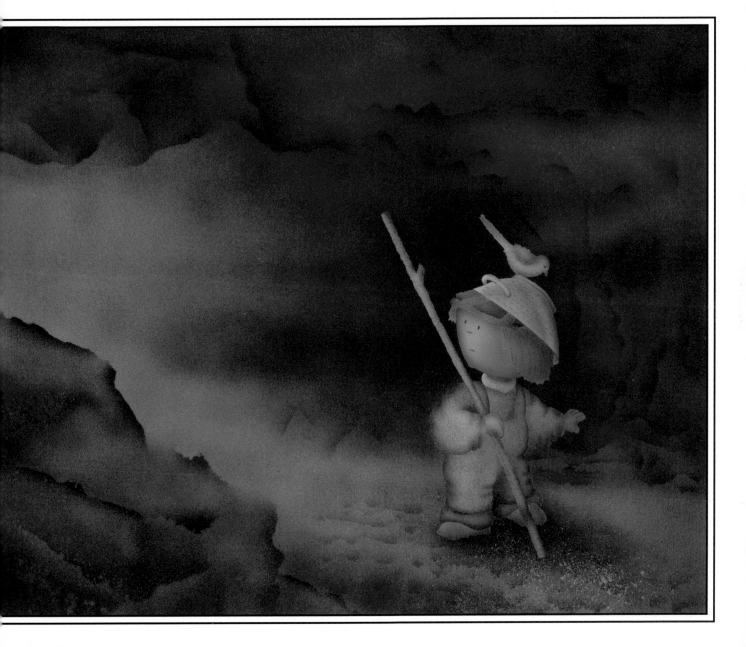

Suddenly a ghost appears.

"Whoo! Whoo! Whoo!" says the ghost.
"Are you looking for treasure? Let me show you mine."
A million bats fly all around me.

"What's your treasure, Simon?" the ghost asks.

I do not wait to answer. I run from the cave.

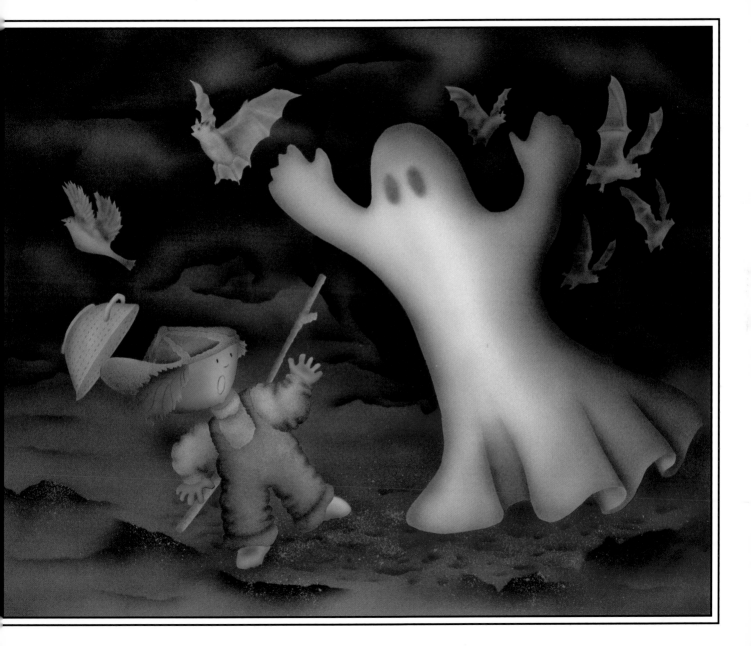

Outside it is night.
It's too dark for me to find my way home.

"Help! Help!" I cry. "I'm lost."

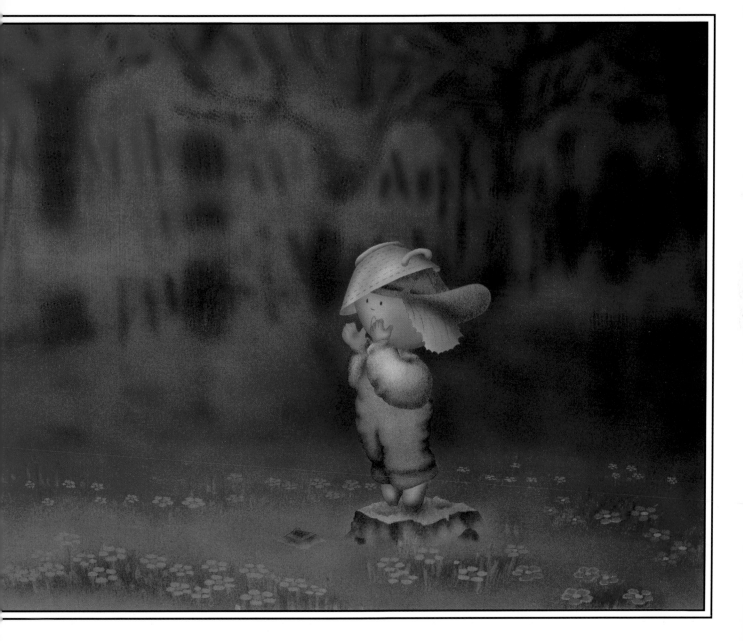

In the distance I hear someone calling my name:
"Simon! Simon! Simon!"

"I'm here," I call back.

My friends have come to find me.

I rush to Marlene and hug her.
I don't need to look further.
I have found my treasure.

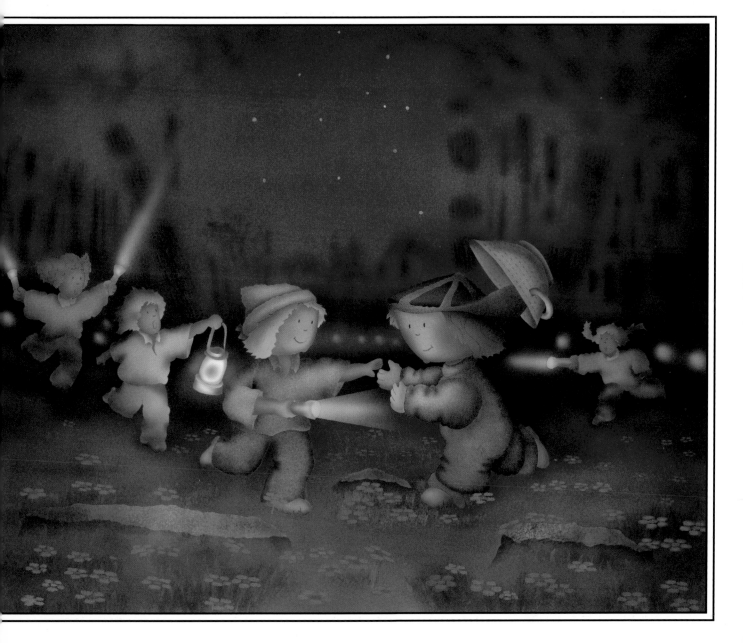

For Alice

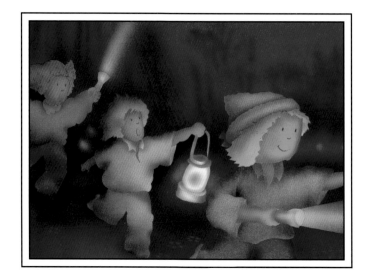

© 1996 Gilles Tibo

Published in Canada by Tundra Books, Toronto, Ontario M5G 2E9

Published in the United States by Tundra Books of Northern New York, Plattsburgh, N.Y. 12901

Library of Congress Catalog Number: 96-60348

Canadian Cataloguing in Publication Data

Tibo, Gilles, 1951–
[Simon et la chasse au trésor. English]
 Simon finds a treasure
Translation of: Simon et la chasse au trésor.
For children.
ISBN 0-88776-376-6 [bound]

 I. Title. II. Title: Simon et la chasse au trésor. English.

PS8589.I26S52613 1996 JC843'.54 C96-900254-8
PZ7.T52sii 1996

00 99 98 97 96 5 4 3 2 1

Canadian Cataloguing in Publication Data

Tibo, Gilles, 1951–
[Simon et la chasse au trésor. English]
 Simon finds a treasure

Translation of: Simon et la chasse au trésor.
ISBN 0-88776-388-x [pbk.]

 I. Title. II. Title: Simon et la chasse au trésor. English.

PS8589.I26S53613 1996 JC843'.54 C96-931520-1
PZ7.T52si 1996

00 99 98 97 96 5 4 3 2 1

[Issued also in French under title: Simon et la chasse au trésor ISBN 0-88776-375-8]

The publisher has applied funds from its Canada Council block grant for 1996 toward the editing and production of this book.

Printed in Hong Kong by South China Printing Co. Ltd.

Vocabulary *Tales*

Protect the Earth!

by Elizabeth Bennett

illustrated by Margeaux Lucas

SCHOLASTIC INC.

New York • Toronto • London • Auckland • Sydney
Mexico City • New Delhi • Hong Kong • Buenos Aires

Designed by Maria Lilja
ISBN-13: 978-0-545-08870-1 • ISBN-10: 0-545-08870-4
Copyright © 2008 by Scholastic Inc.
All rights reserved. Printed in China.

SCHOLASTIC, VOCABULARY TALES™, and associated logos are trademarks and/or registered trademarks of Scholastic Inc.

First printing, November 2008
12 11 10 9 8 7 6 5 4 3 2 1 8 9 10 11 12 13/0

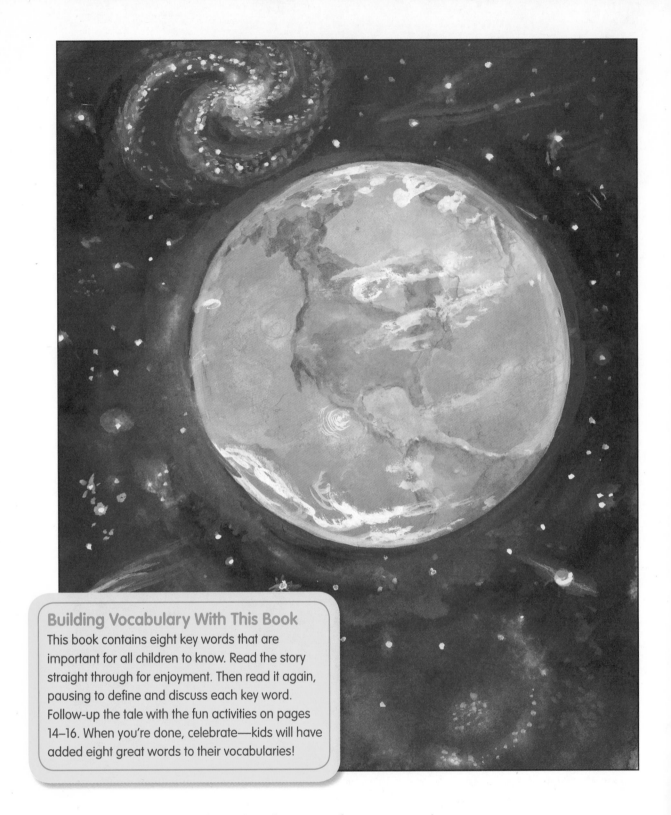

If you could look down from outer space, you'd see our world is a beautiful place.

It's filled with grass and trees and plants—
and hundreds of creatures, from hippos to ants!

The oceans are blue. The mountains are green.
But it's up to us all to help them stay clean.

So, here is a list of some things we can do to keep the world **healthy** for me and for you.

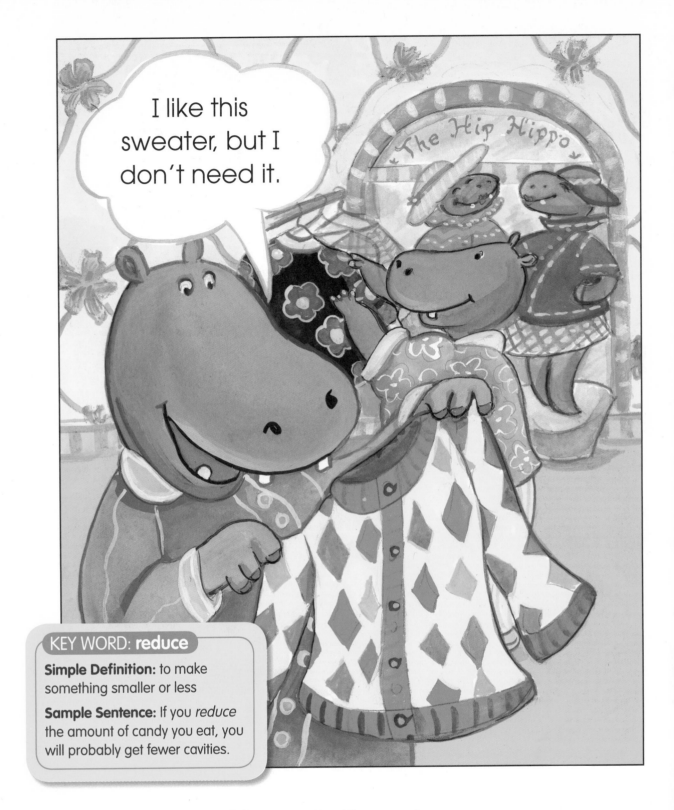

Purchase less. You can, if you try.
Reduce the number of things you buy!

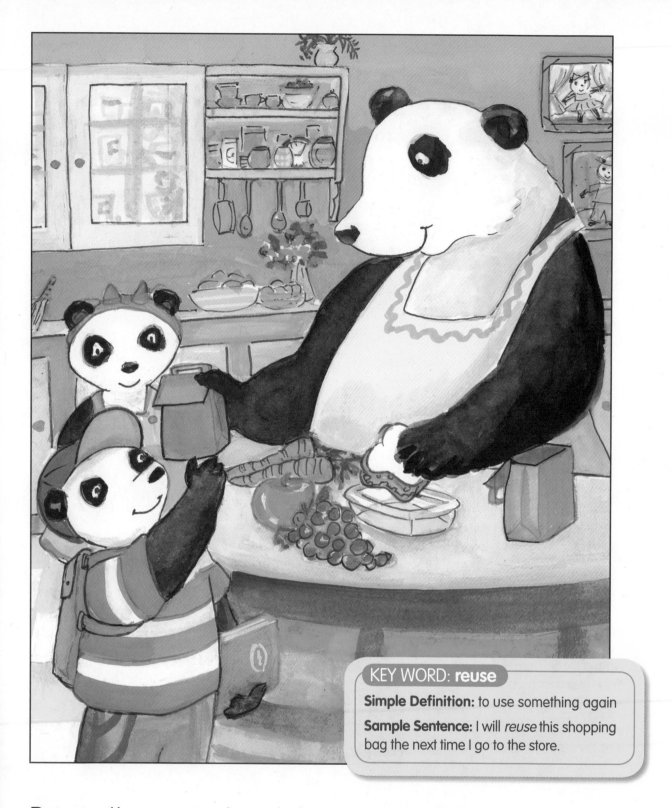

KEY WORD: **reuse**

Simple Definition: to use something again

Sample Sentence: I will *reuse* this shopping bag the next time I go to the store.

Reuse the same lunch bag each day.
When things still work, don't throw them away!

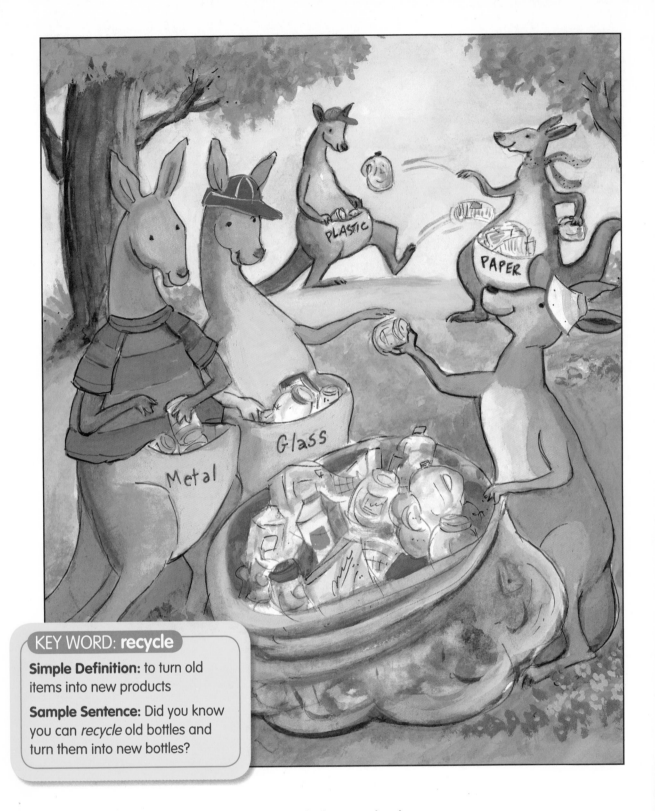

Recycle bottles and old metal cans.
This will help us to save our lands.

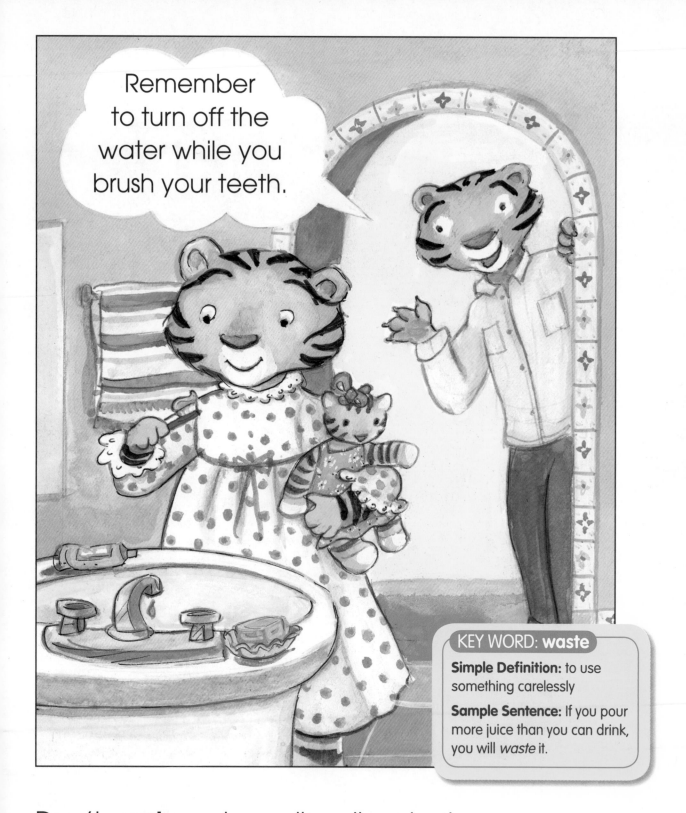

KEY WORD: **waste**

Simple Definition: to use something carelessly

Sample Sentence: If you pour more juice than you can drink, you will *waste* it.

Don't **waste** water—plip, plip, plop!
We need every single drop.

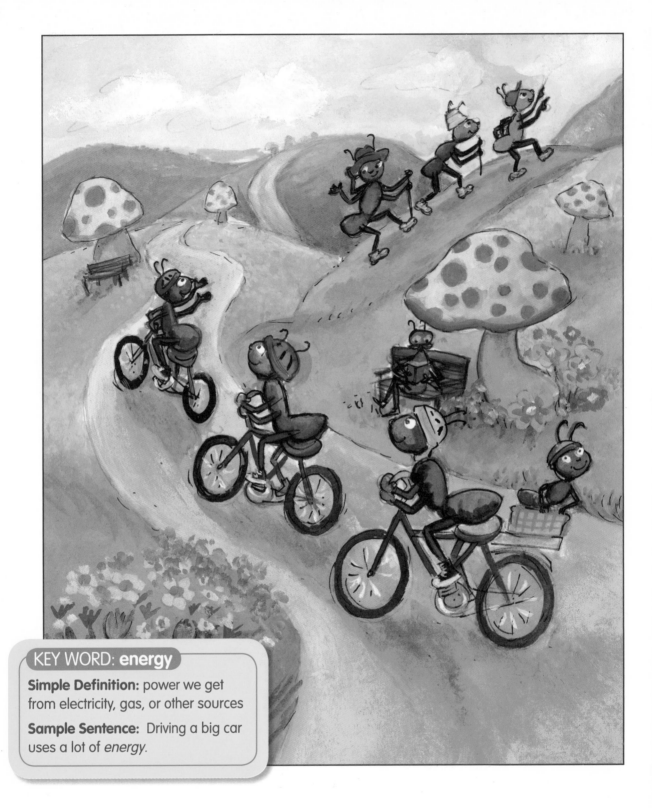

KEY WORD: energy

Simple Definition: power we get from electricity, gas, or other sources

Sample Sentence: Driving a big car uses a lot of *energy*.

Save **energy** by riding your bike.
Forget the car—just take a hike!

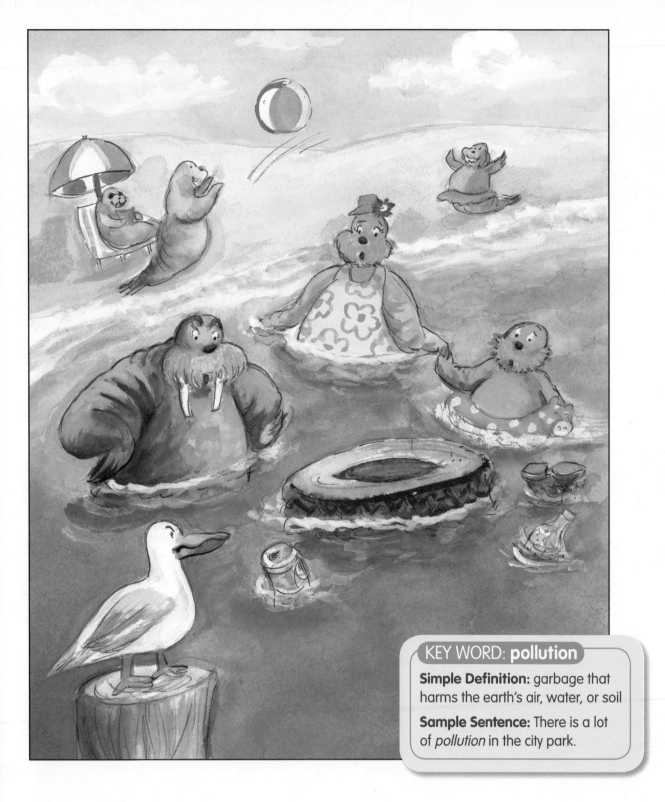

KEY WORD: **pollution**

Simple Definition: garbage that harms the earth's air, water, or soil

Sample Sentence: There is a lot of *pollution* in the city park.

Garbage here, garbage there,
pollution can be anywhere!

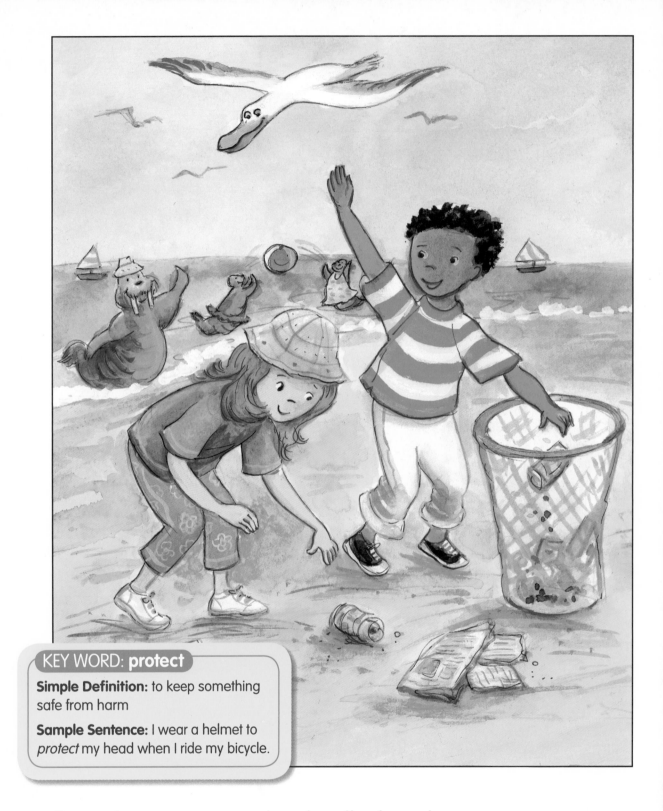

KEY WORD: protect

Simple Definition: to keep something safe from harm

Sample Sentence: I wear a helmet to *protect* my head when I ride my bicycle.

So, when you see trash all about,
protect the earth and toss it out!

If everyone helps, if we pitch in—
the world stays clean and we all win!

Meaning Match

Listen to the definition. Then go to the WORD CHEST and find a vocabulary word that matches it.

1. strong and well
2. to make something smaller or less
3. to use again
4. to turn old items into new products
5. to use something carelessly
6. the power we get from electricity, gas, or other sources
7. garbage that harms the earth's air, water, or soil
8. to keep something safe from harm

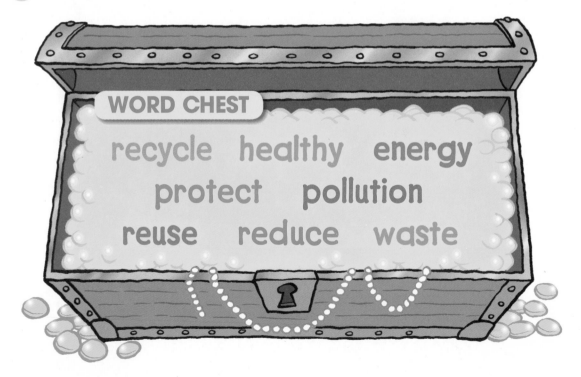

WORD CHEST

recycle healthy energy
protect pollution
reuse reduce waste

Vocabulary Fill-ins

Listen to the sentence. Then go to the WORD BOX and find the best word to fill in the blank.

WORD BOX

waste	healthy	energy	recycle
pollution	reduce	protect	reuse

1. You will _____ that sandwich if you throw it away without eating it.

2. You should always _____ old bottles, cans, and newspapers.

3. A helmet will _____ your head when you ride your bike.

4. Your plant will stay _____ if you give it water and sunlight.

5. Help save _____ by turning off lights you are not using.

6. Carmen decided to _____ the number of water bottles that she buys.

7. The air _____ made the sky look hazy and brown.

8. I like to save wrapping paper so I can _____ it.

15

**Listen to each question. Think about it.
Then answer.**

1. Do you toss out things that you could **reuse**? What are they?

2. Can you think of three ways to save **energy** in your home?

3. What are some things you do to stay **healthy**?

4. What are some ways you can help **reduce** pollution?

5. What can you **recycle**? Make a list.

6. Have you ever seen **pollution**? How does it make you feel?

7. Do you ever **waste** food that you bring to school in your lunch?

8. This book tells about ways to help **protect** the earth. Can you remember all of them?

Extra: Can you think of some more environmental words? Make a list.